The Lexicon of Comicana
by
Mort Walker

AN AUTHORS GUILD BACKINPRINT.COM EDITION

AN AUTHORS GUILD BACKINPRINT.COM EDITION

Published by iUniverse.com, Inc.

For information address:
iUniverse.com, Inc.
620 North 48th Street, Suite 201
Lincoln, NE 68504-3467
www.iuniverse.com

Originally published by Museum of Cartoon Art

Editing and design by Brian Walker
Layout by Abby Gross
Typesetting by Tod Clonan Associates

ISBN: 0-595-08902-X

Printed in the United States of America

Thanks to Jean,
Morgan, Brian,
Jerry, Bob, Neal,
Abby, Ted, and Greg

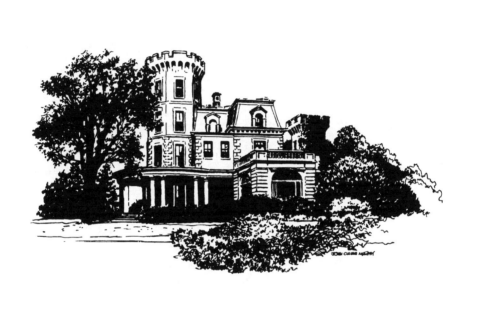

Books by Mort Walker

"Trixie"
"Beetle Bailey" (21 paperback collections)
"Beetle Bailey and Sarge"
"Hi and Lois" (5 paperback collections)
"Sam's Strip Lives"
"Backstage at the Strips"
"The National Cartoonists Society Album"
"Most"
"Land of Lost Things"

INTRODUCTION

SYMBOLS

TYPES OF WRITING

There are many types of writing
besides the modern alphabet system.
They include picture words, symbols,
ideographs, hieroglyphs, and hieratic symbols.

News filler

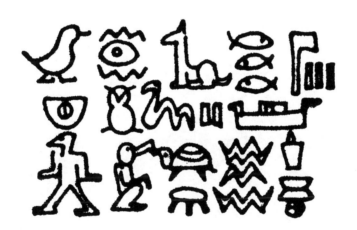

The Museum of Cartoon Art defines a cartoon as "any whimsical, facetious graphic expression which parodies any aspect of human behavior." That's quite a mouthful, and I don't really bite on it.

Every child is a cartoonist. We all begin by drawing crude symbols of people and houses and trees. No one ever starts out as a Rembrandt. But Rembrandt started out as a cartoonist. I'm sure his prideful parents gushed over his first drawings with immediate recognition of what he'd had in mind. "Look! A doggie!"

It wasn't a realistic dog in any sense, but a distillation of the shape of a dog, one that was easily drawn and instantly recognized. It was a cartoon because cartoons are essentially just a group of universally understood symbols put together like a jigsaw puzzle to convey an idea.

Cartoon symbols are being used more and more throughout the world to bridge the language barriers. We see them on road signs, on rest room doors, on automobile dashboards, cameras, instruction booklets, everywhere. They tell us when to go, where to go, and when not to go.

 COCKTAIL SERVICE
BAR · LOUNGE

 SKIING · SKI LODGE
DOWNHILL SKIING
CROSS COUNTRY

 FISHING

 SCENIC VIEW
FILM SERVICE OR SALES

 ICE SKATING AREA OR ARENA
EQUIPMENT · SALES OR RENTAL

 SWIMMING AREA

 SMOKING AREA
SMOKE SHOP

 MEN'S RESTROOM

 HIKERS' TRAIL

 INDICATES FACILITIES FOR
THE HANDICAPPED

 WOMEN'S RESTROOM

 JOGGING

 RANGER STATION,
HEADQUARTERS OR
INFORMATION

 PET EXERCISING AREA

 THIN ICE

 GROCERIES AVAILABLE
SHOPPING

 CHILDREN'S PLAY AREA

 RIDING TRAIL
HORSE RENTAL

The more international we become, the more we need symbols and the more important it becomes that they are universally understood. When they are not understood, strange things can happen.

An American comic book firm got an assignment to produce a cartoon book to instruct Indonesian farmers on the latest agricultural methods. The books were rejected because the Indonesians didn't understand comic book techniques like foreshortening, or drawing close ups within panel lines.

The official pointed out two panels that bothered him most.

"Why have you cut off the farmer's legs? Was he run over by a tractor?" he said of the first drawing, and then dismissed the other with, "In Indonesia we do not have any two legged donkeys."

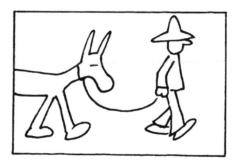

We must take heart, then, when we see people in remote parts of the earth reading Blondie and Peanuts and watching Donald Duck on the movie screen. Not only are they being entertained but they are educating themselves in the world language of symbols.

CHAPTER ONE

BUILDING BLOCKS TO
BETTER CHARACTER DEVELOPMENT

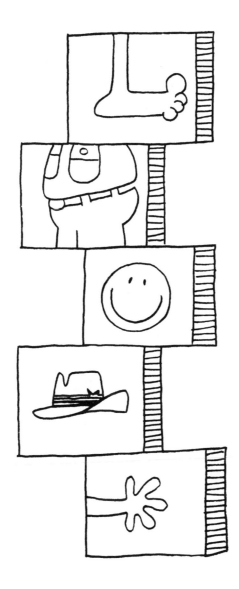

The best place to start anything is at the top, and so our study of cartoon symbols begins with . . .

TETEOLOGY

Often we relate to people more through facial expressions than through language. If someone says, "You jerk!", you must look at his face to see if he's being affectionate or insulting. It is important, therefore, to master the most basic aspects of "teteology."

Happy

Sad

Mad

I don't get any of this.

OCULAMA

The most important elements of teteologic expression is in the eyes, and "oculama" is almost a complete science in itself. The next step into more complicated teteology must begin here.

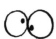

Goofy *Fed up* *Swacked* *Sophisticated* *Surprised*

Proud *Amused* *Asleep* *Unconscious* *You oughta see the other guy.*

ORALOLOGY

If you can say "oralology" then you're using the right part of the anatomy . . . and very well, too! The mouth is the next most vital area of expression. Who among us has not been the victim of a smirk, a sneer or a slerm?*

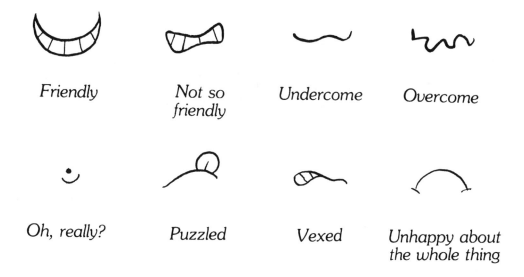

Friendly

Not so friendly

Undercome

Overcome

Oh, really?

Puzzled

Vexed

Unhappy about the whole thing

PROTUSILATION

Related, but a distinct division of oralology, is the language of the tongue. Cartoonists use it a lot, but you can only stomach a few of them at a time.

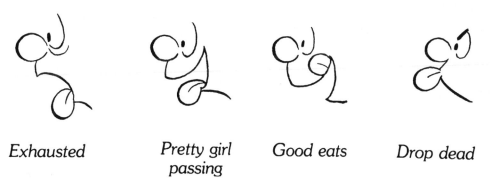

Exhausted

Pretty girl passing

Good eats

Drop dead

* "A slerm," you say, "What's a slerm?" Well, that's why you're reading this book. If you knew what a slerm was (or a grawlix) (or a waftarom) (or a lot of other nonsense) you could have saved yourself the price of this book and the embarrassment of having to carry it out of the store in a plain brown paper bag. You'll find out what a slerm is (etc.) before you know it if you keep reading.

TOTAL TETEOLOGY

Combining the elements of oculama, oralology and protusilation, total teteology is achieved.

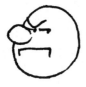 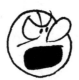 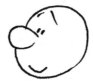 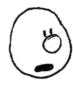 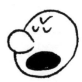

Contumacious *Seditious* *Pliant* *Jussive* *Imperative*

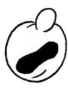 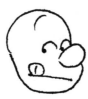 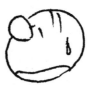 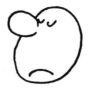 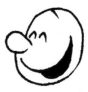

Lassitude *Covetous* *Satiated* *Supercilious* *Insouciant*

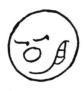 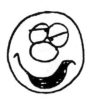

Smirk *Sneer* *Slerm* *Odious* *Nebulous* *Inebriated*

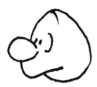 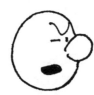 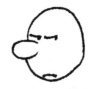 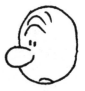

Fatuous *Jocund* *Expostulatory* *Surreptitious* *Indigent*

Sometimes to convey the precise flavor of various teteology, a few props are extremely helpful:

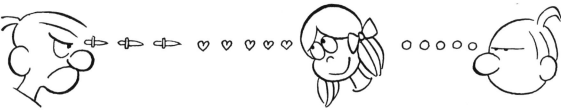

Get lost

In your arms

I feel neutral about the whole thing.

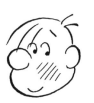

Embarrassment

Like it says

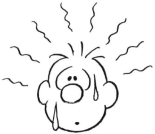

Overheated

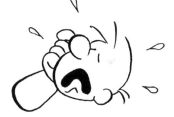

La Deluge

Didn't do his homework

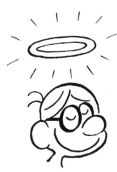

Did

Wait `til teach sits in her chair.

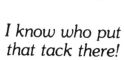

I know who put that tack there!

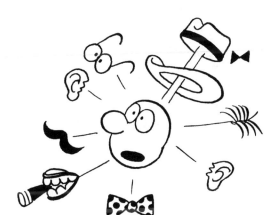

"YOU PAID GOOD MONEY FOR THIS BOOK?!"

MORFS

Now let's get into the body. (My favorite part.) Many books have been written on body language, how people reveal their feelings with their posture, but almost nothing has been written on how to get that body. Hardly anyone realizes that bodies are built of beans, balloons and boxes. A "morf" for a man, for instance, might consist of a balloon for the head, a larger one for the upper body and an even larger one for the lower torso . . . plus some sticks for appendages. To change sexes just add a few more balloons. Cheaper than going to Sweden.

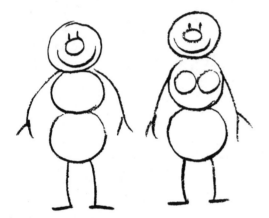 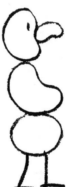

Man and woman morfs using balloons

Man and woman morfs using balloons and beans

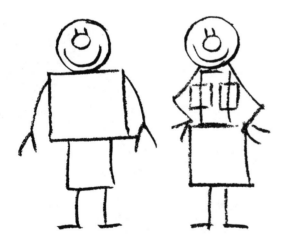 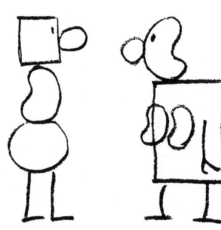

Man and woman morfs using balloons and boxes

Man and woman morfs using balloons, boxes, and beans

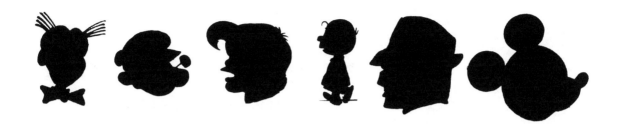

A great editor once said, "A good comic character should have such a definite morf that he is recognizable even in silhouette." He was morf or less right. Can you identify these six famous silhouettes? Answers below.

Hats are a handy addition to the morf and help in identification. How many characters can you identify by their hats only? (There are no prizes.)

Dagwood, Popeye, Li'l Abner, Charlie Brown, Dick Tracy, Mickey Mouse

TYPES

After you get the hang of morfs, you're ready to elaborate and create some individuals or personalities. Probably the most used type over the years has been the "lame-brain." Since the brain isn't visible, a clue is needed to tip off the reader as to the character's IQ. For some strange reason, the clue has become buck teeth. Although doctors have never determined a direct relationship between acumen and malocclusion, the device has become firmly entrenched in comicana. It has even spread to show business. Remember Edgar Bergen's "Mortimer Snerd," or some of Jerry Lewis' skits? You'll find it everywhere. Here are some of the examples from the comics.

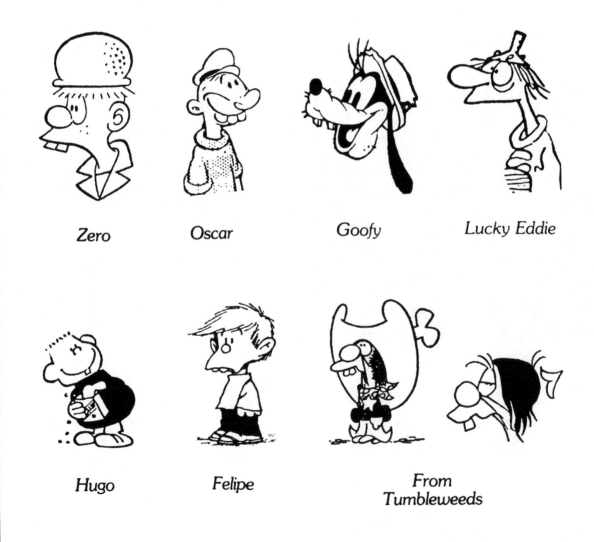

Zero *Oscar* *Goofy* *Lucky Eddie*

Hugo *Felipe* *From Tumbleweeds*

In the interest of equal time, the way to show that a character is smart is to give him glasses. (Note: there aren't as many smart guys as dumb guys in the comics.)

Clark Kent

Julian

Plato

Miss Prunelly

Rip Kirby

STEREOTYPES

Clothing has a way of identifying people. Adam was the first to recognize this. It's easy to tell a cop by his uniform and a housewife by her apron, but what do we do with other professions and categories of people? In comics we need instant identification, so cartoonists invented stereotypes. Even if the dress code isn't strictly adhered to in real life, comic characters know how to dress for the occasion.

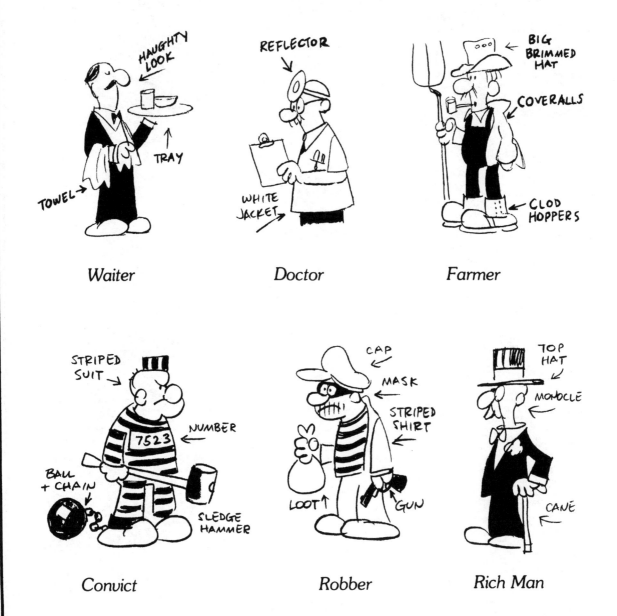

Waiter Doctor Farmer

Convict Robber Rich Man

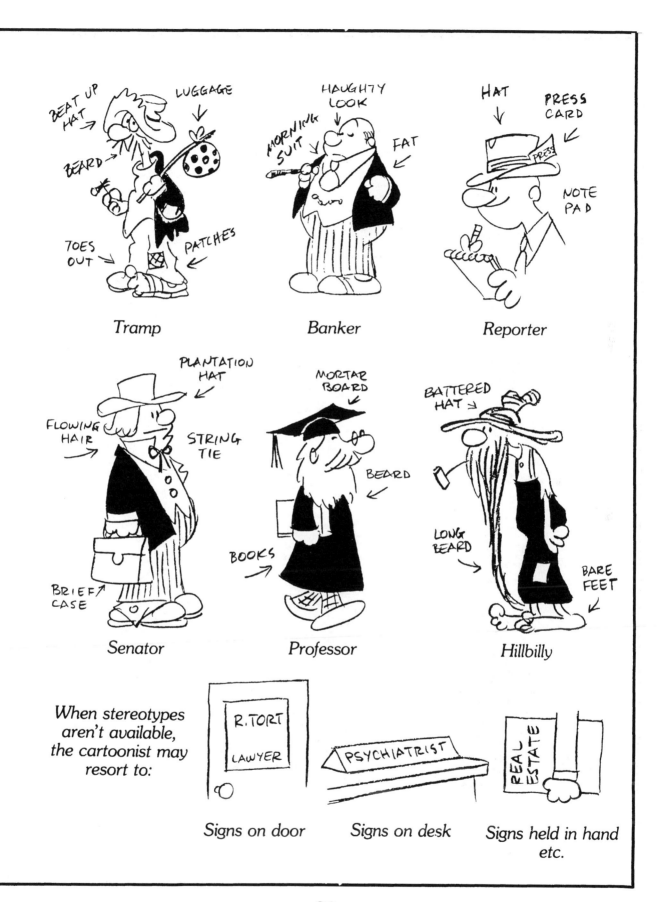

Tramp

BEAT UP HAT
LUGGAGE
BEARD
TOES OUT
PATCHES

Banker

HAUGHTY LOOK
MORNING SUIT
FAT

Reporter

HAT
PRESS CARD
NOTE PAD
PRESS

Senator

PLANTATION HAT
FLOWING HAIR
STRING TIE
BRIEF CASE

Professor

MORTAR BOARD
BEARD
BOOKS

Hillbilly

BATTERED HAT
LONG BEARD
BARE FEET

When stereotypes aren't available, the cartoonist may resort to:

R. TORT
LAWYER

PSYCHIATRIST

REAL ESTATE

Signs on door

Signs on desk

Signs held in hand etc.

POLITOTYPES

Editorial cartoonists especially have developed many symbolic characters over the years to help readers understand an idea. Many of these characters, such as Santa Claus, have become part of our culture and are used in many different ways.

Our poor bruised and battered world.

John Q. Public

John Q. Taxpayer

Congressman

Uncle Sam

John Bull

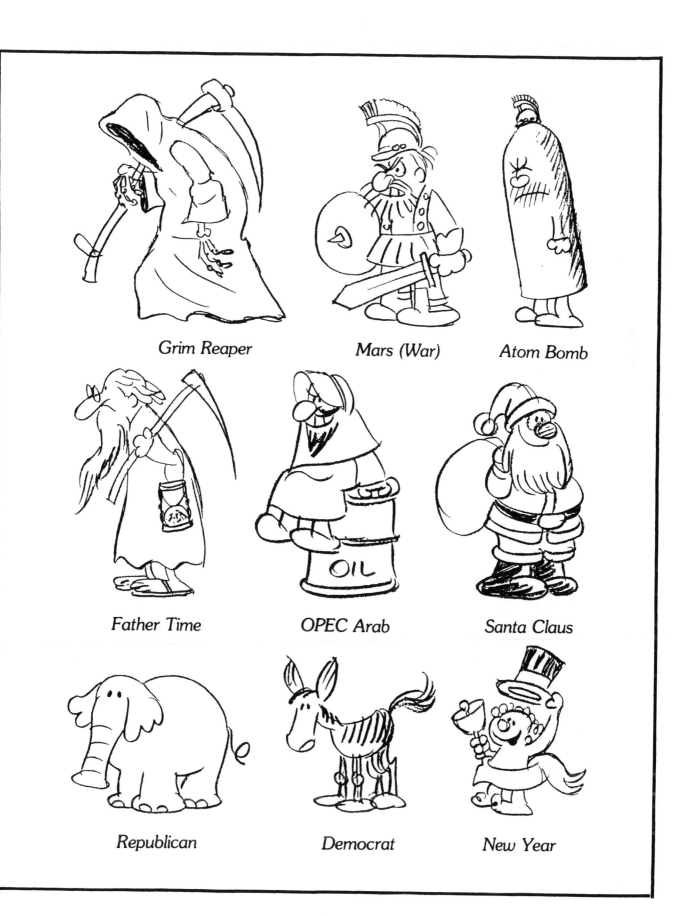

Grim Reaper

Mars (War)

Atom Bomb

Father Time

OPEC Arab

Santa Claus

Republican

Democrat

New Year

CHAPTER TWO

INDICIA

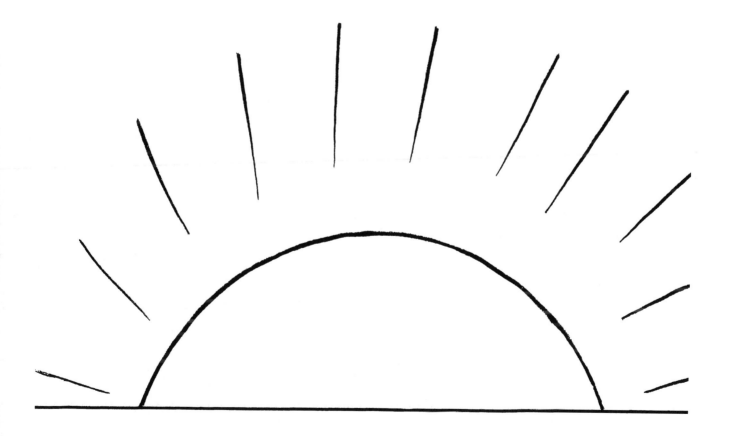

EMANATA

Now that we have our characters, there's a lot more we can do with them to show what's going on inside them. Those of you who believe in mental telepathy should not be at all surprised at the things cartoonists have emanating from their characters. For instance:

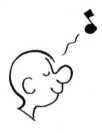

It's a beautiful morning.

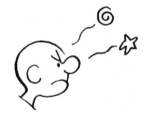

Wow! Look at that coming down the street!!!

Hey! She's getting in a car with some other guy!!

Plewds are one of the most useful devices to show emotion. Here's one example:

Lady discovers her slip is showing.

A few more plewds — her shoulder strap broke.

An eight-plewded lady. We'll leave her plight to your imagination.

Other emanata reveal internal conditions.

Man with
squeans —
slightly
drunk.

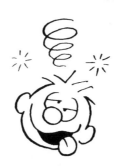

Man with
squeans and
a spurl —
loaded!

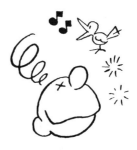

Squeans, spurl,
crottle eyed,
surmounted by
thrush — it's
"never-again" time!

Emanata can come from things as well as people to show what's going on. Here are a few:

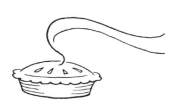

Waftarom
Shows that the
pie smells good.

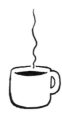

Indotherm
The coffee
is hot.

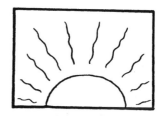

Solrads
You can almost
feel the warmth
radiating from
the sun.

Lapsebeams
Used by cartoonists
to show that time has
passed.

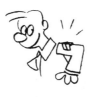 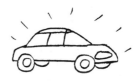

Neoflect
Lets us know that something is spanking new.

HITES, VITES, DITES AND BRIFFITS

Sounds like a law firm but actually it's a little more firm than that. And straighter. Some artists use a ruler to execute these lines because the straighter they are, the more effective. The "ite" family comes in three flavors:

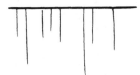

*"**Vites**" are used to show a shine on a floor and are drawn vertically.*

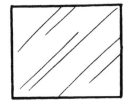

*"**Dites**" indentify a window or a mirror and are drawn diagonally.*

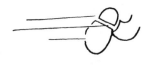

*"**Hites**" indicate speed and are drawn horizontally.*

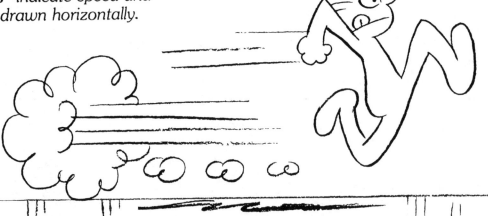

The more hites, the more speed. Add a few "briffits" (dust clouds) for better effect. Note that briffits are permissible even if the floor is marble and highly polished.

Uphites can also be used vertically to show that someone is so suprised or frightened he is launched from terra firma.

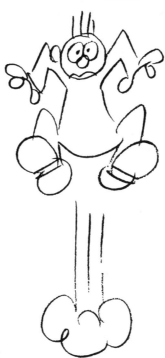

Great care should be taken to draw the hites going UP. If carelessly drawn with a DOWN stroke, disastrous results can occur.

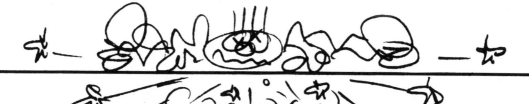

SPHERICASIA

This is a difficult art, extremely hard to draw, which sends most cartoon-ists scurrying into the dark depths of their drawers looking for a compass which is seldom found, forcing them to trace the edges of ink bottles, coffee cups, quarters or anything of the same roundness needed in the drawing. A *Complete Sphericasia*, called a "*Swalloop*", is required in such cases as a person taking a hell of a swing at a golf ball. Usually the *Swalloop* comes within a "*Whitope*" of being a complete circle. This is necessary to show where the Swalloop begins and ends.

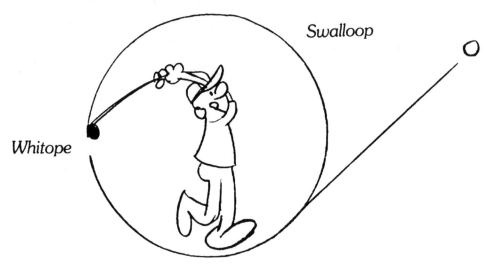

Swalloops can also be used horizontally to illustrate round-house swings with fist, bat, check-grabbing (rare), etc.

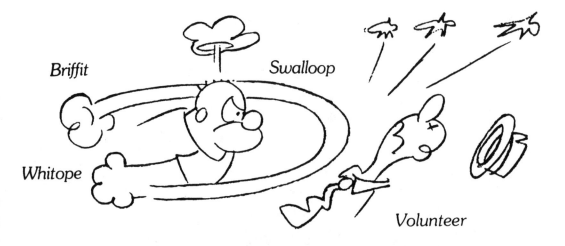

Lesser *sphericasia* can also be used to show movement. *"Agitrons"* (When a character must show a reaction to some situation) and *"Direct-a-trons"* (to show where someone has gone or wants to go) are well-known members of this group.

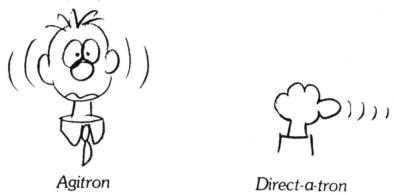

Agitron *Direct-a-tron*

Sphericasia need not always be strictly circular in design. Be creative. Bend 'em any way you want. Give 'em a name and add a tron.

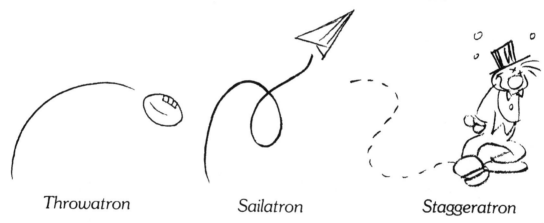

Throwatron *Sailatron* *Staggeratron*

These handy little marks can be used to help the ladies along their way.

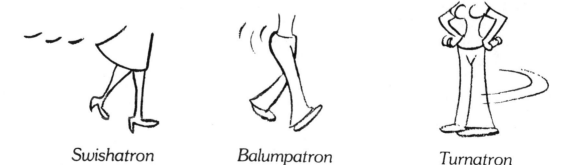

Swishatron *Balumpatron* *Turnatron*

CROSS HATCHING

Cartoonists have always used shading in their drawings. Some shading is fancy, some sloppy, but all of it is used to fill up empty corners and convince editors they're working. This shading is done with a variety of pen strokes and is called "cross hatching." You can almost identify a cartoonist by his cross hatching. Each is as individual as his signature.

Chester Gould
"Dick Tracy"

E.C. Segar
"Popeye"

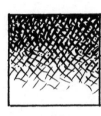

Dik Browne
"Hagar"

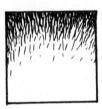

Harold Gray
"Little
Orphan
Annie"

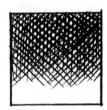

George
Herriman
"Krazy
Kat"

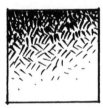

George
McManus
"Bringing
Up Father"

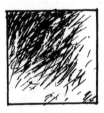

Billy De Beck
"Barney
Google"

Fontaine Fox
"Toonerville
Trolley"

J.R. Williams
"Out Our
Way"

Roy Crane
"Wash
Tubbs"

Bill Gallo's
Toothbrush
splatter

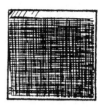

Rube
Goldberg's
screen

Frank Johnson
"Boner's Ark"

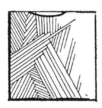

Gus Arriola
"Gordo"

John Fischetti's
Daub (old
sock dipped
in ink)

Ben's
Day

Coquille
Board

Double Tone
Craftint

Wash
Halftone

Ross Board

Dry Brush

Stipple

Ink Blot

LUCAFLECT

How can you tell if an area or object is round, wet or shiny? One very common gimmick is to show a window reflected in the object. This is *"Lucaflect."* It doesn't matter if a window is nowhere near. You will probably never be questioned about it. If you are, clam up and give only your name, rank and serial number . . . or go out and rent a window.

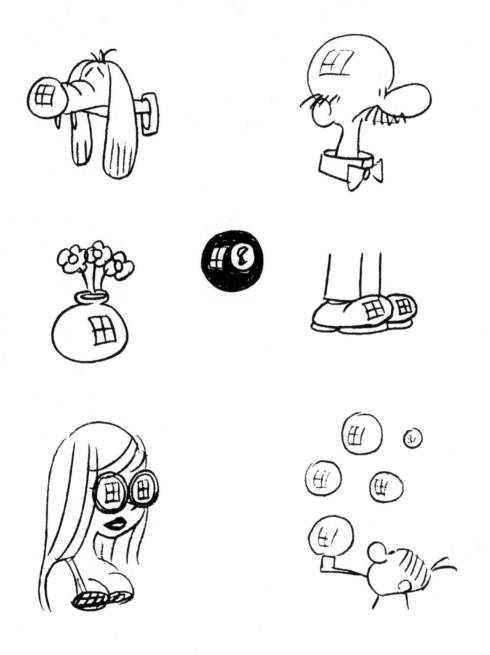

36

BLURGITS

Various components can be combined at times, such as hites, reverbatrons, agitrons, etc., to produce other effects. Blurgits are produced by a kind of stroboscopic technique to show movement within a single panel, or to produce the ultimate in speed and action.

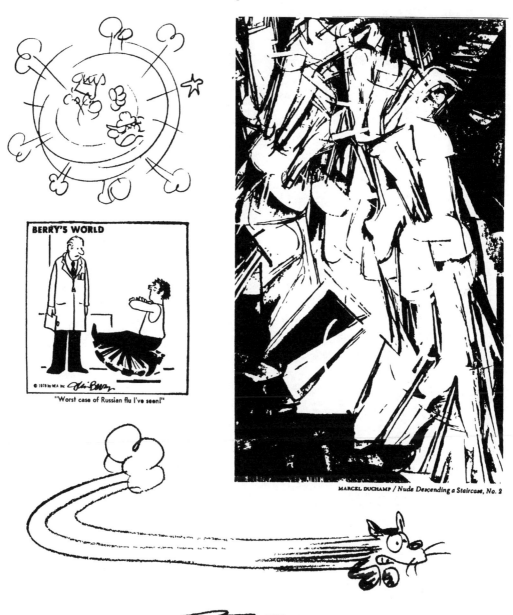

MARCEL DUCHAMP / Nude Descending a Staircase, No. 2

A blurgit of catastrophic proportions.

FUMETTI

This is the Italian word for "balloon" and, consequently, the word they use for "comic strips." Balloons are the things that float above a character's head and contain what he's thinking or saying. Each cartoonist has his own shape of balloon, and there are as many styles of fumetti as there are ink blots on a Monday morning.

They can also be animated to put across certain emotions.

The "AT&T" fumetti is used to show a voice being relayed electronically.

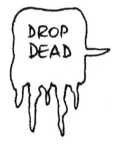

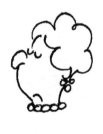

The "Frigidaire" fumetti conveys a cold-shouldered snub, among other things.

A "Boom" balloon pictorializes yelling. The volume is determined by the size of the serrations.

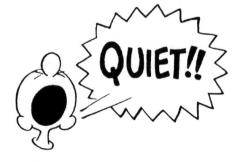

The gift of x-ray vision is given you courtesy of the "Cumulus" balloon. It allows you to see the thoughts inside a character's head.

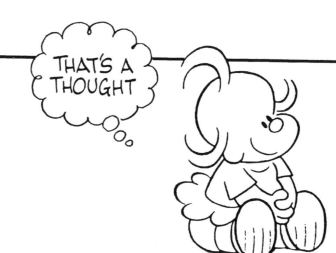

The variety is endless, fortunately, allowing me to put out a revised and expanded edition of this book next year and make this book obsolete. Here's a teaser.

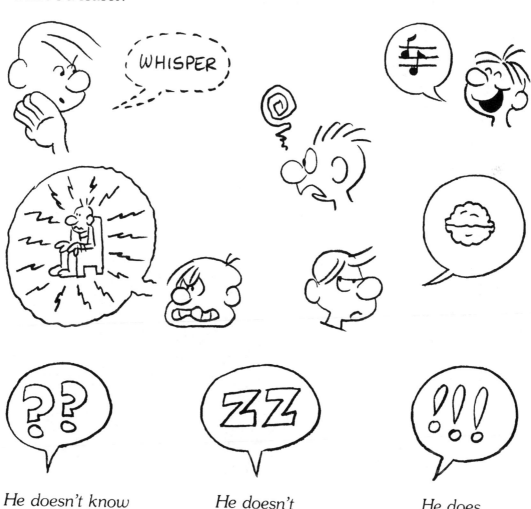

He doesn't know what's happening

He doesn't care

He does

EARLY FORMS OF FUMETTI

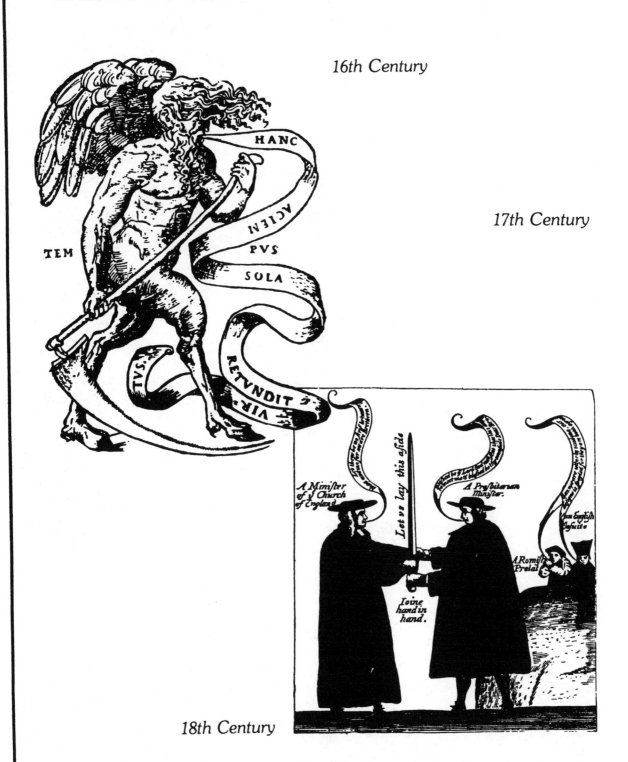

16th Century

17th Century

18th Century

BORDERS

Some cartoonists don't use any borders at all. Probably because they are not proud owners of a ruler. Some do their drawings in vignette . . . that is, let them fade away at the edges like a well-worn throw rug. Other artists like to do creative borders. i.e.:

However, we want to discuss regular border-art so get out your serutan.

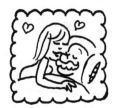

This border encloses a dream sequence or an event that occured in the past.

This one shows something is happening somewhere else at this moment.

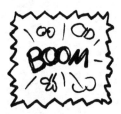

An explosive scene. Someone or something blowing up.

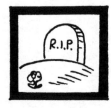

Sometimes necessary following the explosive scene. May he rest in peace.

Irregular borders

Oval borders

No borders

BORDERS (continued)

Wandering borders

MORALITY PLAY

Villains always dress in black, have large black mustaches and are mean looking. (Wouldn't that be convenient in real life?)

Heroes, on the other hand, wear white; no facial hair, and are strong and pleasant.

Fathers of teenagers are mousy, easily manipulated, bald, have very small mustaches, and look worried.

ONOMATOPAEIA

Cartoonists are especially fond of onomatopaeia (words that imitate natural sounds). Comic strips are literally strewn with PLOPS, BLAMS, ZOTS, OOFS, SWOOSHES and ZOOMS. What's more, they take great pride in interpreting new sounds all the time. Listening outside a cartoonist's studio you would constantly hear him vocalizing the piece of action at hand . . . a bat hitting a ball, FWAT! . . . a foot kicking a garbage pail, K-CHUNKKK! He will try many sounds before he settles on the one that satisfies him. Then he will add more meaning to the sound by animating the lettering.

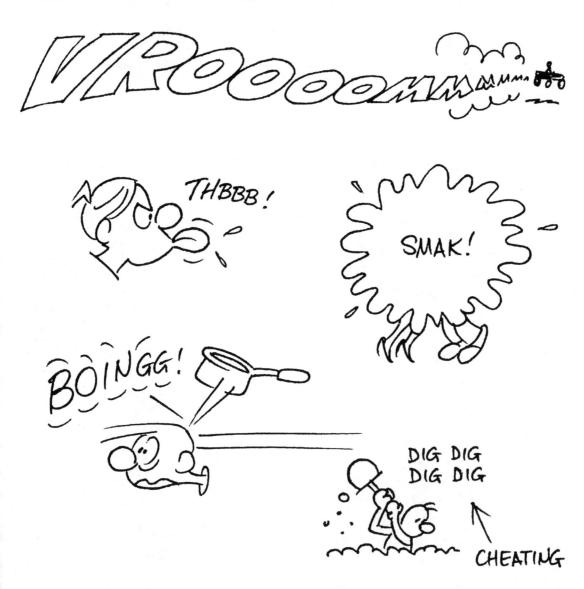

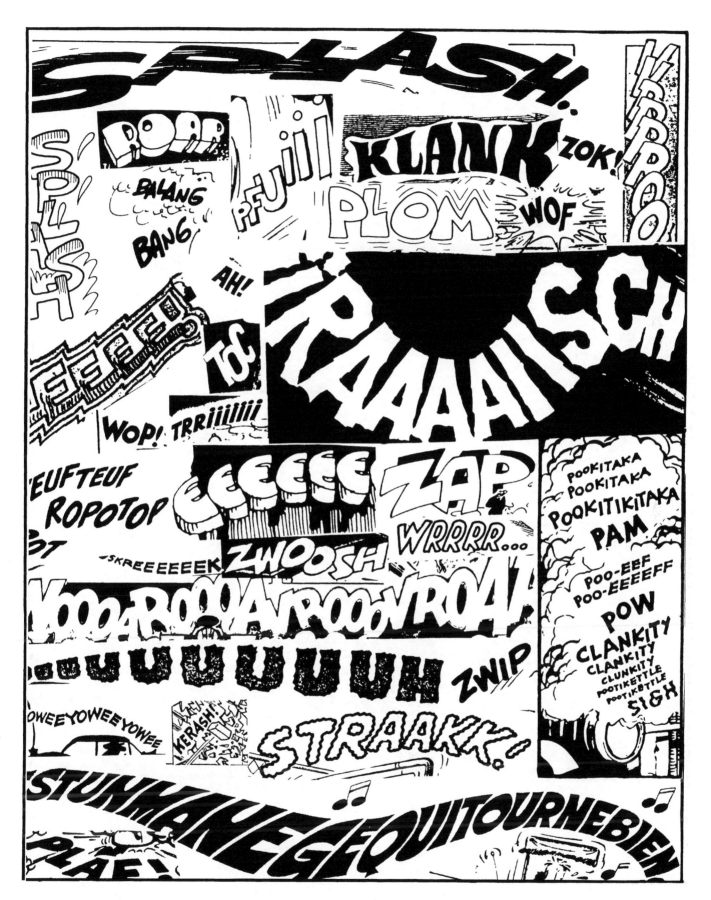

SYMBOLIA

There are a number of uncategorized indicia that must be memorized if one is to become a true expert in comicana.

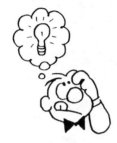

Person getting an idea must have a lightbulb overhead.

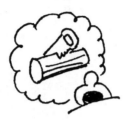

Snoring is dramatized by a log being sawed

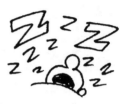

. . . or merely with a Z or lots of z's if he's really asleep.

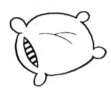

Pillows have little ears on them and some ticking showing.

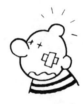

Bandages are a cross of tape, and bumps protrude noticeably, highlighted by emanata.

Paint cans always have drippings over edge.

Rugs must show a fold.

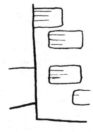

Never show all the bricks in a wall, only a few to give the impression.

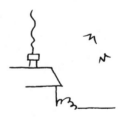

Distant birds should always dot a sky in the form of inverted W's.

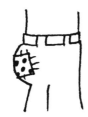

*Patches are
usually polka
dot. (Be sure
to show stiches.)*

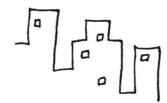

*Distant buildings
should only show
a smattering of
windows.*

*Bones are
always this
shape, whether
a tibia
or a femur.*

*New things
are recognized by
their
price tags.*

*Bags must
announce what's
in them.*

*But booze
must go by
code.*

*A piece of
paper? Or
money? It all
depends on the
label.*

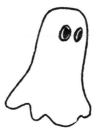

*No self-
respecting ghost
would be caught in
his nightshirt . . .
except in the comics.*

*A kid running
away always
has a stick
with a bandana
(sling) on it.*

Footprints duplicate the shape of shoe bottoms, naturally.

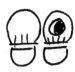

Worn spots in shoe are like knotholes, they show more thickness to the sole than is possible.

You can't buy 'em like this anymore, but hot dogs are still linked in the comics.

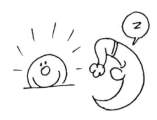

The sun comes up in the morning and the moon at night in cartoon-world. (This is the only schedule most cartoonists can adhere to.)

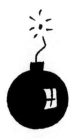

In comicland this is a bomb, even though there may have never been a real bomb like this.

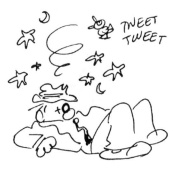

The loser in the altercation needs one black eye, an x'd-out one, some quimps, lesser sphericasia, topped off with a tweeting bird.

Married men are often depicted like this. (Note "Lucaflect".)

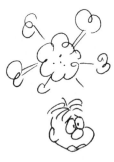

This poor guy had a great idea but something just changed that.

This is a toothache.

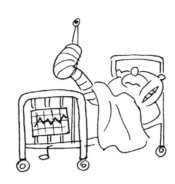

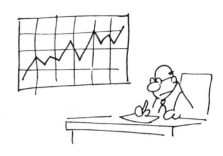

Cartoonists must be sloppy in the kitchen because all their cakes seem to have drippy frosting.

A hospital bed is shown with a fever chart on the foot . . . and feet are shown in an elevated cast.

You'd never know it was a business office unless you show a progress chart on the wall.

PAPERWORK

Typewritten letter

Handwritten note

Newspaper

Stack of paper

WATERWORKS

Wake

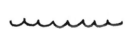

Dive

In the swim

rain

Ocean

MALADICTA

Even in today's permissive society many four letter words are not permissible in the comics. Even though profanity may be used in other sections of the paper, people feel that, since children read cartoons, the comic section should be inviolate.

Cartoonists, therefore, have had to develop acceptable substitutes. A first sergeant would lose a lot of his charm if he said, "Gee whiz, Beetle. You make me so terribly mad!" So the creative mind came up with a variety of *"jarns," "quimps," "nittles," and "grawlixes"* to help convey a sergeant's strong emotion and add color and dimension to his personality.

 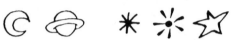

Jarns **Quimps** **Nittles** **Grawlixes**

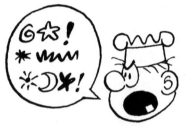

Normal cussing

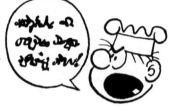

A variation using ob-stensibly obliterated epithets.

World War II style is becoming obsolete with today's relaxed taboos.

The ultimate

The Doonesbury Style (Just come right out and say it)

52

WHERE WILL IT ALL END?

The comic strip "Sam's Strip" often used a plethora of comicana to satirize cartoon techniques as did Saul Steinberg in his painting "Comic Strip". How many can you find?

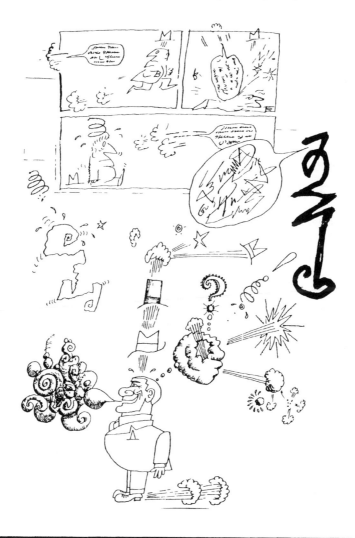

CHAPTER THREE

THE RIGHT TO DISASSEMBLE

LICENTIA

Obviously, it would be dangerous and downright messy if just *everyone* was allowed to go around using all these symbols and things.

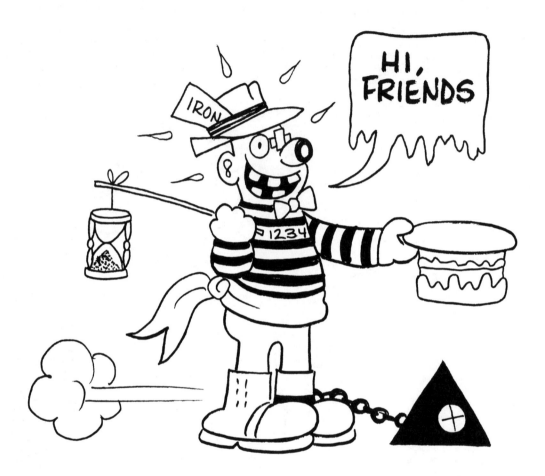

A commission was set up to issue licenses and review a person's qualifications. A simple test is required of the applicant. He must sit at a drawing board for one hour, staring at the wall in front of him, being very careful not to make one mark on the paper in front of him. He must also call someone on the phone for no reason at all and lie down on a couch and fall asleep without dropping the pencil and pad of paper poised on his lap. Having succeeded in these basic, but all important, requirements, he is then given the following license:

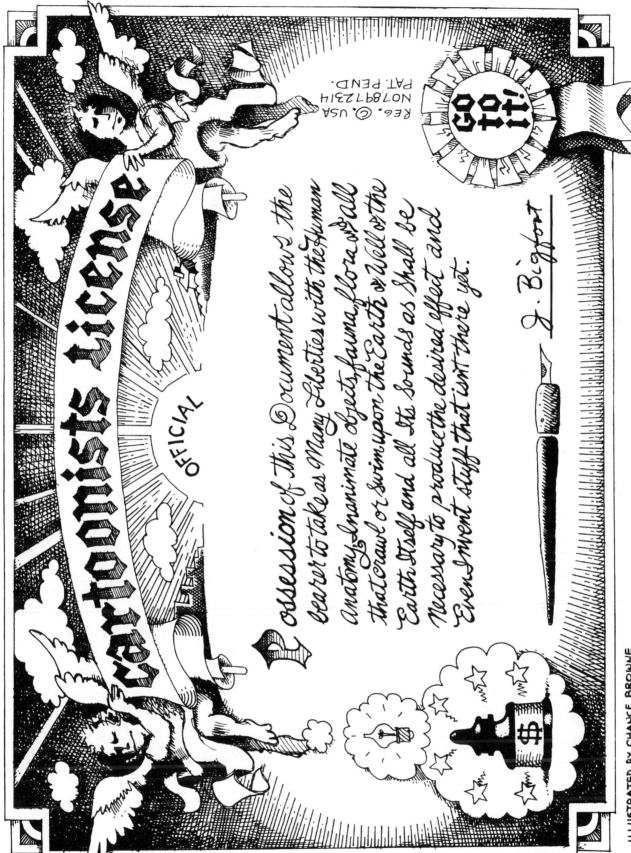

Cartoonists license

OFFICIAL

REG. © USA
N0789172314
PAT. PEND.

GO IT!

Possession of this Document allows the bearer to take as many liberties with the human anatomy, inanimate objects, fauna, flora or all that crawl or swim upon the Earth or Well or the Earth itself and all its sounds as shall be necessary to produce the desired effect and even invent stuff that isn't there yet.

J. Bigfoot

ILLUSTRATED BY CHANCE BROWNE

MUSCLOMA

Assuming that you passed the test, and are now the proud possessor of a cartoonist's license, here's what you can do with it. (Besides THAT!)

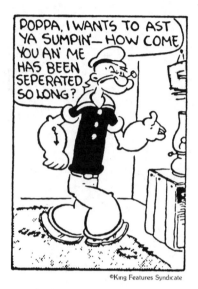

Popeye by Segar

Invert muscles or add more.

Alley Oop by Hamlin

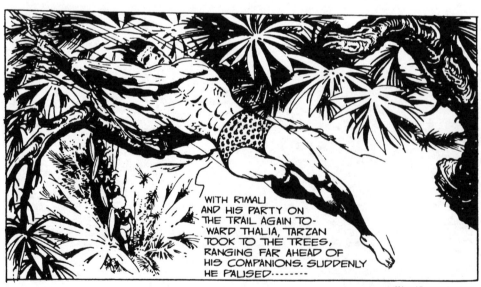

Tarzan by Hogarth

MORTALITY

A license allows a cartoonist to control growth rates of his characters. Some prime examples:

 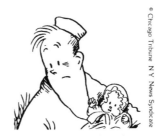

Little Orphan Annie has not changed her age (or her dress) in 50 years. Skeezix, on the other hand, began as a baby in 1921 and is now a grandfather.

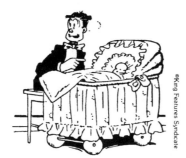

Blondie and Dagwood had a baby in 1934. Forty six years later, he is a teenager.

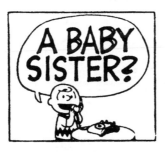 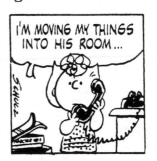

Charlie Brown had a baby sister who is now a schoolgirl although Charlie himself hasn't aged a day in 30 years.

There you have the whole spectrum: no growth, normal growth, delayed growth and irregular growth. The only thing we haven't documented is reversed growth, but it probably exists somewhere.

MAYHEMIA

Heap various forms of Mayhem upon comic characters, but be sure to establish that the condition isn't permanent.

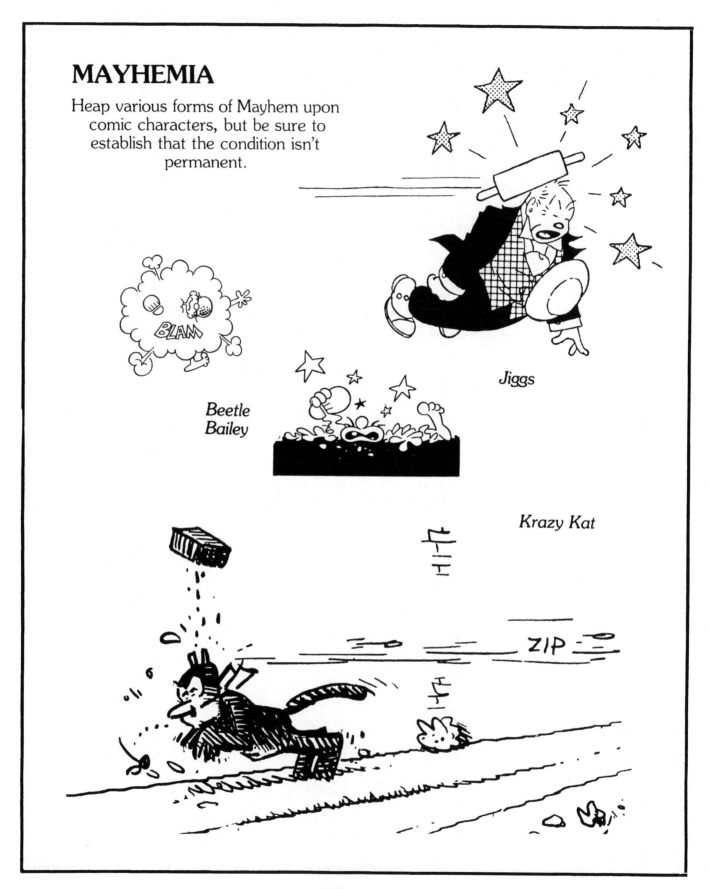

Jiggs

Beetle Bailey

Krazy Kat

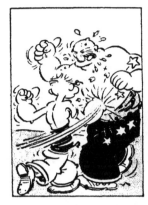 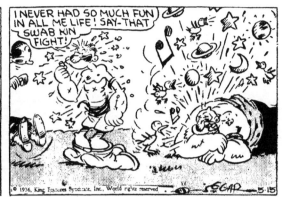

Popeye

Fearless Fosdick

PHYSIOCOMICA

There are so many things a cartoon-ist's license allows you to do:

*Pictures on the wall
can come to life.*

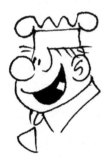

*A character can
have few teeth in
one panel.*

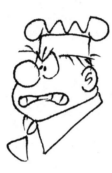

*And plenty in
the next.*

*Or no mouth at all
if you want that
certain stupid look.*

*Stretch
eyeballs.*

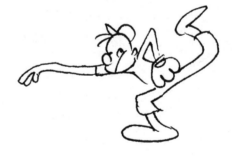

*Or stretch arms,
legs, etc. to
emphasize action.*

TELECOMICATIONS

In some strips
flowers can talk.

So can rocks.

And even schools

Let the reader
see the character's
thoughts.

Or enable one
character to read the
thoughts of others.

Or allow the
character to *forget*
he's in a comic strip
and talk directly
to the reader.

Or let people and
animals talk to
each other.

Or let animals talk
to other animals.

DIGITONS

A cartoonist's license allows you to give 'em a hand even if you're all thumbs.

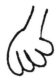

Some cartoonists draw all four fingers.

Some draw three.

Some don't draw any.

Virgil Partch uses all the fingers left over.

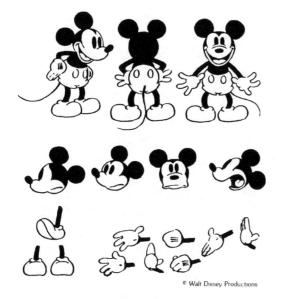

© Walt Disney Productions

I think Walt Disney started the three finger trend that most cartoonists use today. Disney, of course, was drawing animal paws which made the three fingers authentic. It began to look natural and everyone began doing it. Think of all the ink that has been saved over the years by cartoonists eliminating that extra finger.

TAGATONS

When all the tricks of comicana fail, a cartoonist's license permits you to resort to labeling. The editorial cartoonist is the prime labeler, but comic strippers do plenty of it, too.

"Speaking of Orbits."

Smokey Stover

Dick Tracy

CHAPTER FOUR

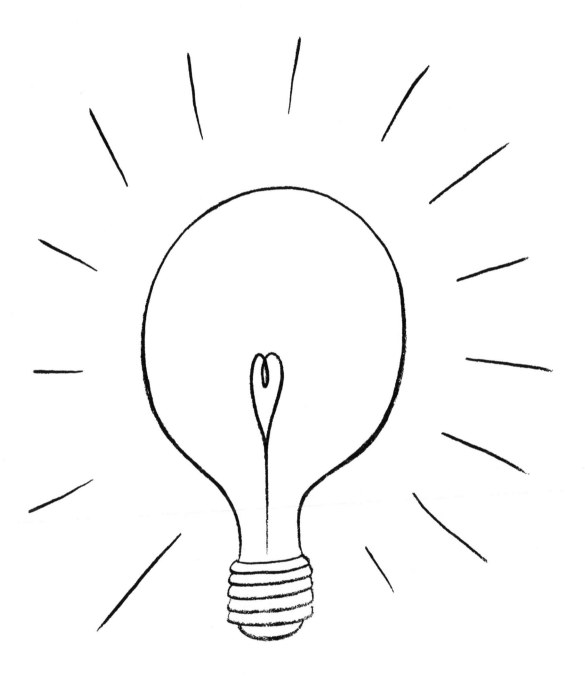

TRITE AND TRITE AGAIN

You'd think that once a gag has been done no one would want to see it the second or the third or the fourth time. Certainly not the fifth, or sixth . . . This is evidently not true in cartoondom where situations appear over and over again and never seem to lose their appeal. What's more, the situations aren't often based on reality. There probably never was a desert isle with two shipwrecked souls receiving messages in a bottle. Nor have I ever seen a booth where a lovely lass sold kisses for charity. But these scenes have been repeated for years in cartoon form and have become a form of "schtick." Laughter is sometimes a "learned" response. We feel comfortable with familiar themes. We know it's time to laugh when we see one of these trite scenes and it, unfortunately, only encourages the cartoonists to do more of the same . . . because there are sure plenty of them. Some notable examples follow:

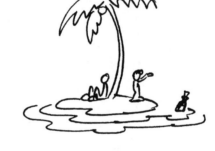

Desert Isle

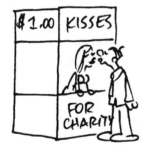

The kissing booth

*Proposals on one knee
with parents behind
the drapes*

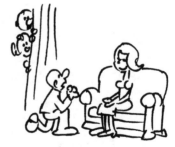

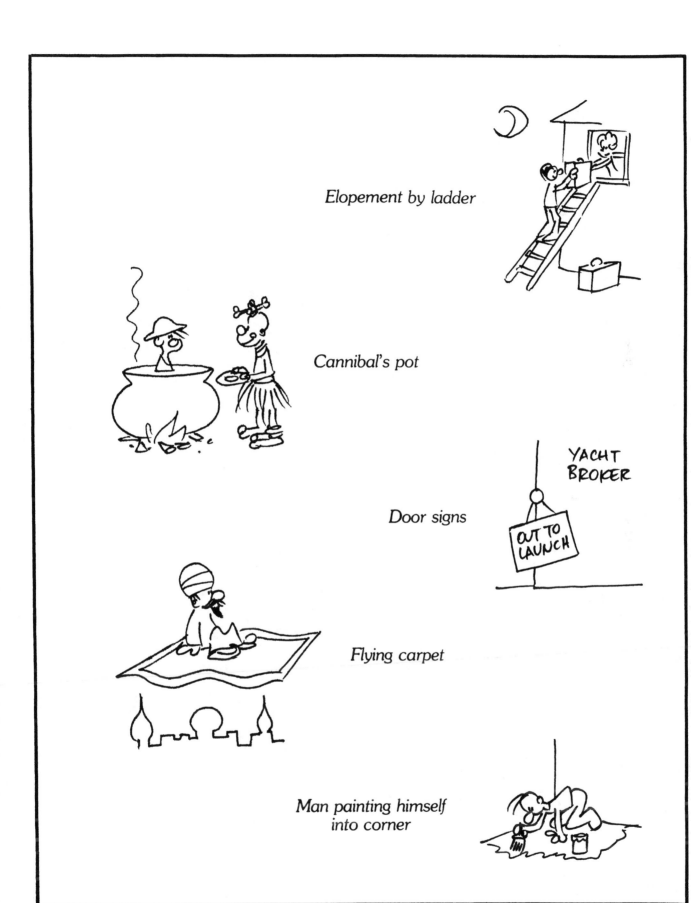

Elopement by ladder

Cannibal's pot

Door signs

Flying carpet

Man painting himself
into corner

69

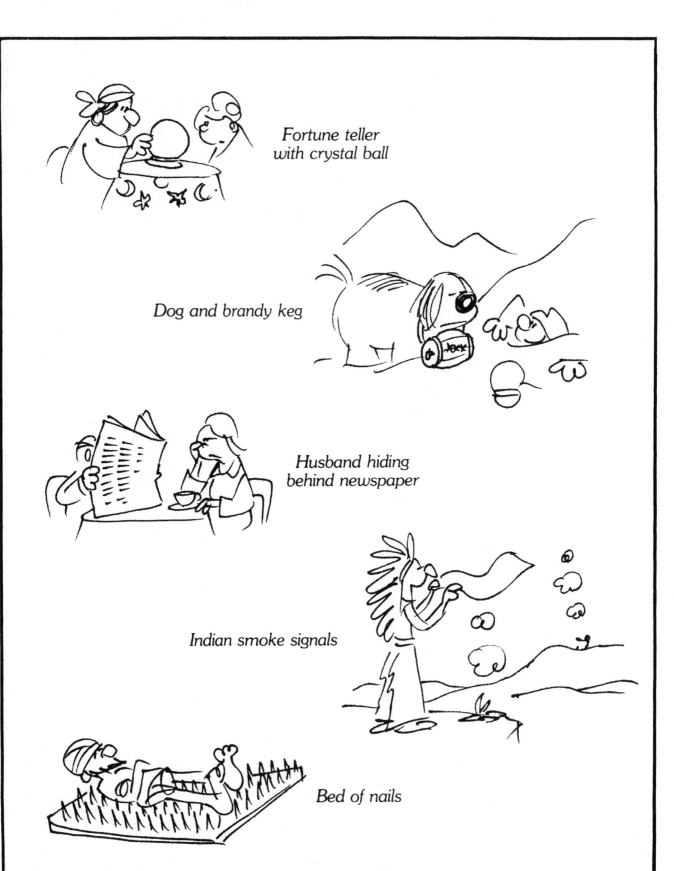

Fortune teller
with crystal ball

Dog and brandy keg

Husband hiding
behind newspaper

Indian smoke signals

Bed of nails

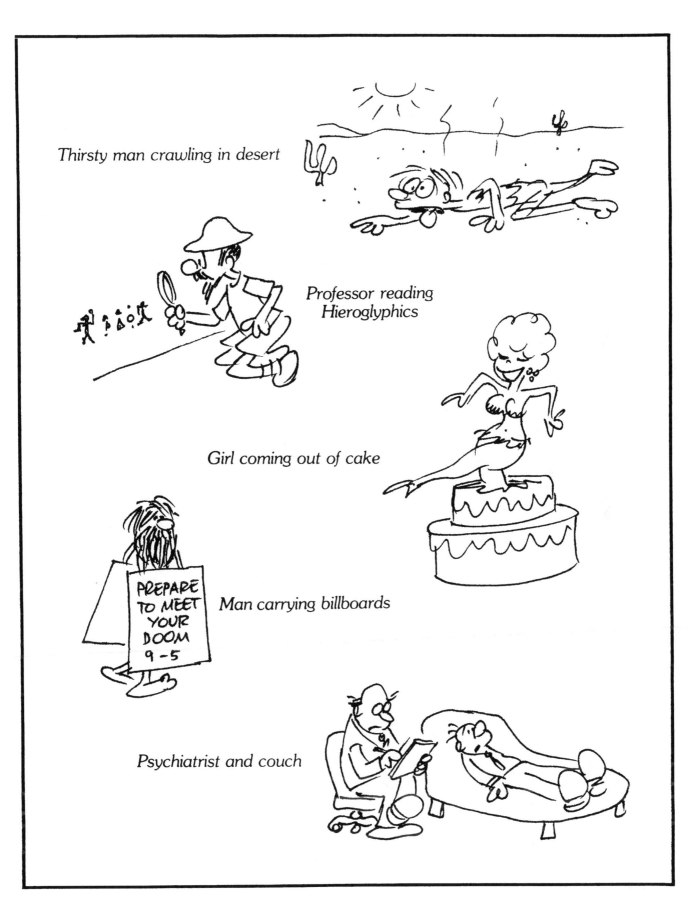

Thirsty man crawling in desert

Professor reading
Hieroglyphics

Girl coming out of cake

Man carrying billboards

PREPARE
TO MEET
YOUR
DOOM
9 - 5

Psychiatrist and couch

not to mention:

Tree surgeon treating tree like human patient.

Person eating grapefruit with juice squirting on someone.

Friends admiring girl's engagement ring with jeweler's eyeglass.

Groom carrying bride over threshold.

Husband waiting on street corner for wife.

Baseball (or other object) on tv screen crashes through screen into room.

Mother washing out kid's mouth with soap for saying dirty word.

Little boy watching sister and boyfriend on couch till they bribe him to leave.

Sign painters being affected by sign they're painting.

Wet paint signs.

Deep sea diver seeing fish do crazy things.

Pretty girl sitting with older gent in cocktail lounge saying something stupid.

People on yacht in salesroom getting seasick.

Safari with natives carrying (incongruous) things on their heads.

Children building snowman with father's clothing and tools.

Astronauts landing on the moon and finding earth-like objects.

The moon as green cheese.

Flying saucer creatures talking to earth objects as though they were people.

Outer space creatures asking "take me to your leader".

Lighthouse gags involving salesmen selling unusable items.

Painless dentist.

Treating a penquin's feathers like formal clothes.

Kangaroo with baby in pouch doing something like a real kid.

"You should have seen the one that got away," gags.

Medical students viewing operation and making show business comments.

Car pulling trailer that is covered with house-like attachments (awnings, window boxes, etc.)

Prisoner getting cake with file in it.

Kid and cookie jar.

Crook robbing store but acting like a customer.

Toys coming to life.

Sailor desiring tattoo with unusual message.

Eskimos and long nights.

Kids having to practice musical instruments while others play ball.

Man commenting on wife's new dress.

Cavemen leaving drawing or message on wall to confuse future generations.

Talking dogs.

Someone weighing themselves and getting personal message on fortune card.

Fortune cookies with personal messages.

Man asking boss for raise.

Neighbors borrowing things.

Jokes about hippie's clothing or hair.

Husbands carrying huge stacks of wife's shopping.

Husbands or kids making mess of kitchen while "helping" wife.

"Humanizing" computers.

New father pointing out baby through window in maternity ward.

Wife or girlfriend visiting prisoner and talking through screen.

Mailmen and dogs.

Tunnel of love.

Doctor tapping person's knee with hammer.

Doctor with mirror on head.

Women talking lengthily on telephone.

Women buying hats.

Treating women as sex objects . . . or men as henpecked.

Treating husbands like mischeivous little boys.

Treating kids like they are smarter than their parents.

Treating animals like they're smarter than humans.

Assigning mothers-in-laws, policeman and congress the enemy role.

Secretary taking dictation on bosses lap.

CHAPTER FIVE

Now that you have been enlightened to the basic principles of comicana, you may want to put your new-found knowledge to practice. If you can't be talked out of it, then continue to study the next few pages which contain some necessary lessons in cartooning. The joking is over. It is time to get serious and get down to work. I'm leaving now. Will you please turn off the light when you go out?

HOW TO DRAW A STRAIGHT LINE

A lot of people say to me, "I've always envied cartoonists. I can't even draw a straight line." Okay, I'll show you how it's done.

Well, it looks straight to *me*. Anyway, there are a lot more important things in life than sitting around drawing straight lines.

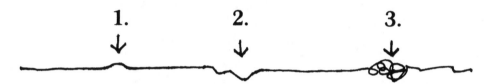

Three common errors in drawing straight lines.

How to hold a pen

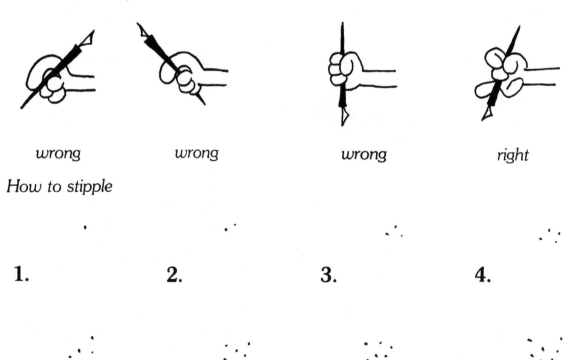

How to stipple

How to draw stick figures

 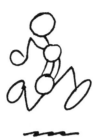 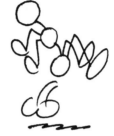

How to draw caricatures

 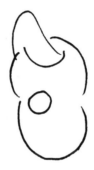 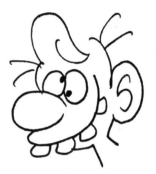

Photo of subject

1. Exaggerate shape of head

2. Choose outstanding feature and exaggerate it

3. Fill in other features

How to draw pretty girls

 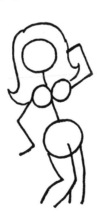 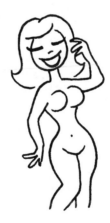 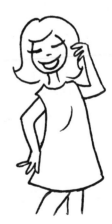

Start with stick figure

Add other elements

Finish off full figure

Reluctantly add clothes

How to draw feet

1. 2. 3. 4. 5.

Drawing feet is easy and fun. Just start with the basic shape and add toes. The trick is knowing when to stop.

How to draw hair

1. 2. 3. 4.

How to draw eyes

1. 2. 3. 4.

How to draw ears

wrong wrong wrong wrong wrong right

How to draw shadows under shoes

 1. **2.** **3.** **4.** **5.**

When to draw silhouettes

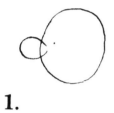 **1.** 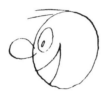 **2.** 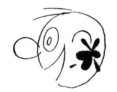 **3.** **4.**

How to draw comic strip balloons:

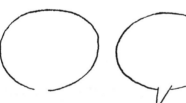 **1.** 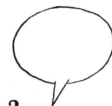 **2.** 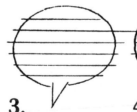 **3.** 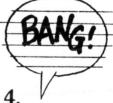 **4.** **5.**

How to draw a beer

 1. **2.** **3.** 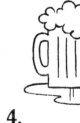 **4.**

How to draw a man drawing a nude

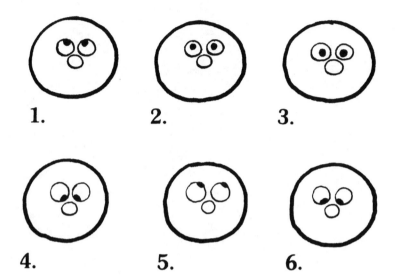

1.　　　　2.　　　　3.

4.　　　　5.　　　　6.

How to draw a face starting with a circle

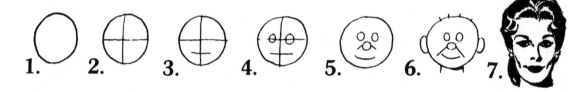

1.　2.　3.　4.　5.　6.　7.

How to draw shadows

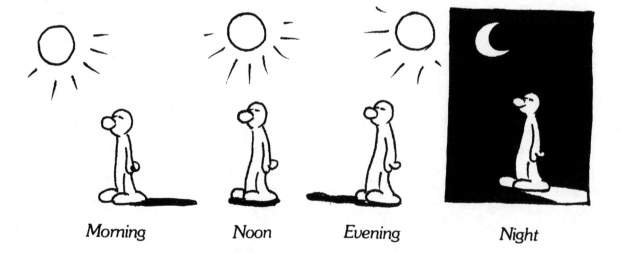

Morning　　Noon　　Evening　　Night

How to draw noses

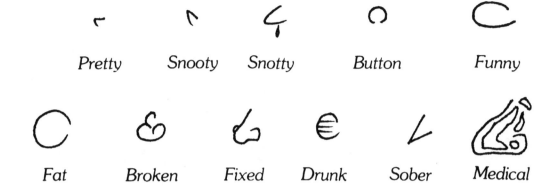

Pretty Snooty Snotty Button Funny

Fat Broken Fixed Drunk Sober Medical

How to draw buttons on shirts

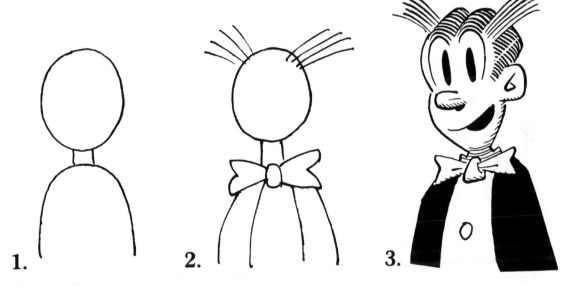

1. **2.** **3.**

How to draw wrinkles

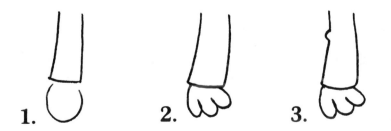

1. **2.** **3.**

When to draw clouds

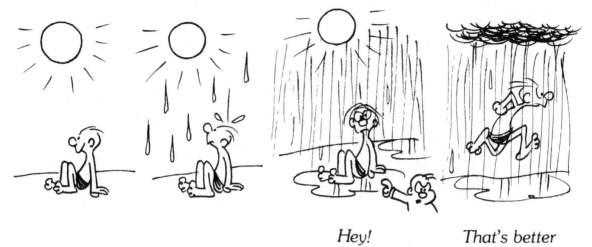

Hey! *That's better*

How to draw smoke

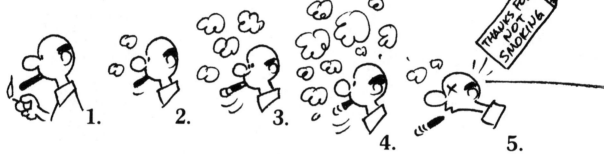

How to draw perspective

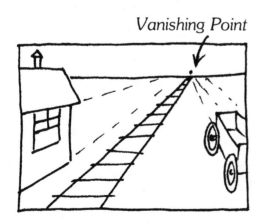

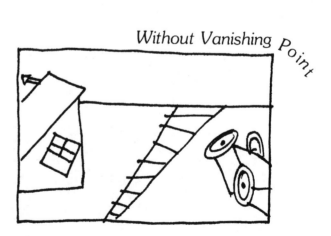

Common mistakes

*Not leaving
enough room
for lettering*

*Trying to erase
before ink is dry*

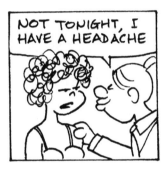

*Having balloon
pointer going
to wrong person*

*Drawing things
out of proportion*

*Drawing things
out of season*

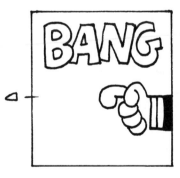

*Leaving out
important
elements*

CHAPTER SIX

ADDENDUMS (and more dumb things)

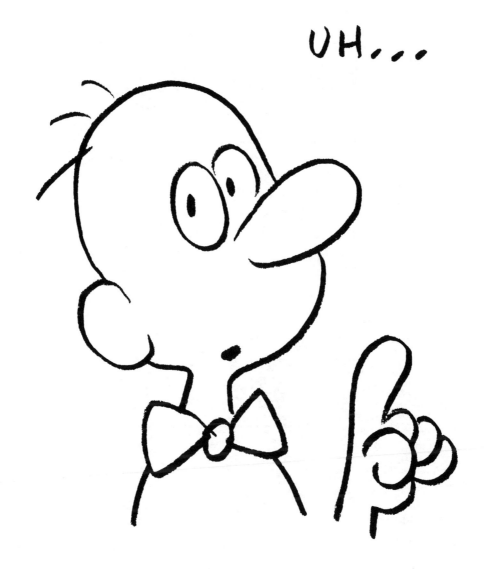

ART-SPEAK

It isn't enough for art to speak for itself. It must be spoken about.

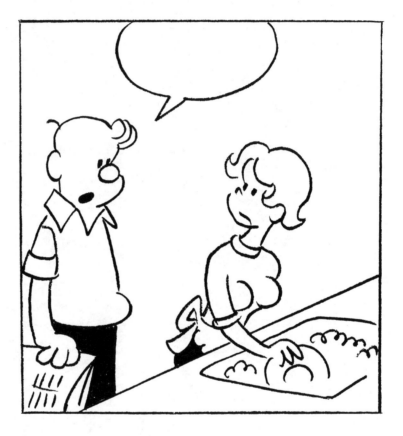

Every book nowadays must contain two elements to insure the book's success. No book can make the best seller list without a liberal dose of sex and psychology. We've already touched on sex so, herewith, our psychological offering:

The artist here is making an agressive statement about women and marriage in general. Note the domestic accoutrement in her sphere of dominance while he obviously has been enjoying a respite. The background has been cleverly eliminated to heighten the emotional exchange betwen the two figures. The postures suggest an erect confidence on his part while she is recoiling in submissiveness. Slashing across the scene like a thunderbolt, the sink symbolizes centuries of distaff enslavement. You know immediately who these people are, their values, their role in society. Their clothing broadcasts middle class mores and the whole scene reverberates with the inner antagonisms of frustrated personalities caught up in the system with no hope of extricating themselves. Their names are probably Hi and Lois, or some mundane combination cloying with cutsieness. It must be signalized that the artist chose two colors for his artwork, black and white, denoting the symplistic attitudes of his subjects. The penwork, too, is reminiscent of the Walt Disney school of art often categorized as "Mickey Mouse Art," or less than chic. The all over effect is one of direct immediacy, not implying any subtle inferences nor requiring any degree of sophistication for cognizance. Its appeal is to the neophyte or the puerile and therefore not worthy of extensive comment.

APPENDIX I
FURTHER READING

THE NEW YORK TIMES, MONDAY, NOVEMBER 27, 1967

A Parisian Cartoonist Sketches Universal Language in Symbols

By JOHN L. HESS
Special to The New York Times

PARIS, Nov. 26—Man is developing a universal language of symbols, in the view of some linguists here.

Jean Effel, a Paris newspaper cartoonist, is convinced of it, and recently, with the help of two Sorbonne professors of Oriental languages, he presented his findings to a fascinated audience at Unesco House.

The people at the United Nations Educational, Scientific and Cultural Organization were particularly interested because of the difficulties they have had in developing alphabets for hundreds of languages spoken by illiterate peoples.

The Western alphabet, all agree, is inadequate to express the sounds and, above all, the pitch and rhythm of these languages, which convey a rich variety of meaning.

Every good African proverb can be expressed on a drum, an African expert told the session, which was sponsored by the International Typographical Association.

Existing Forms Adapted

Among the solutions proposed are a variety of phonetic symbols. The new art of phototype-setting makes it easy to create an unlimited number of combinations, it was pointed out.

But a sign language, like Chinese ideograms and Egyptian hieroglyphics, bypasses the problem, since it has nothing to do with speech.

Mr. Effel calls his language a discovery rather than an invention because in fact, he says, he uses nothing but symbols men have already developed for communication without words.

In his own trade, Mr. Effel said in an interview, a host of wordless conventions have appeared. A falling object, for example, is defined by two or three diagonal strokes:

The same strokes, inside a rectangle such as a window-pane, designate glass:

Guidebooks, international road signs and mechanical drawings are also rich sources of symbols, but one of the best, Mr. Effel said, is mathematics. In any language, he pointed out, $2 + 2 = 4$, and $2m^2$ means two square meters; advanced mathematicians can exchange highly abstruse ideas without uttering a word

Over several years, Mr. Effel collected 10,000 symbols in use. Among them, he said modestly, were no more than 2,000 of the 5,000 most basic words, but his work so far was only tentative

Grammar posed fewer problems than one might think. Take Mr. Effel's translation of "To be or not to be: that is the question":

In the first symbol, he explained, the reverse "E" is a mathematical symbol meaning "it exists." The curve above indicates a verb. Mr. Effel adopted this convention from the notation that round road signs widely used in Europe generally call for action or forbid it. Rectangular signs convey passive information, such as the name of a town; hence a straight line overhead would designate a noun—in this case, "existence."

By similar reasoning, a circumflex angle designates an adjective, and a similar figure with a crimp in the anglo marks an adverb.

The second symbol, "Y," is the road sign for a fork ahead. By itself, it denotes "either/or." With a straight line overhead, it would be a noun: "choice." A curve overhead would make it a verb, "to choose," and a question mark inside the fork would mean "to hesitate."

A Slash Means 'No'

The third symbol is the same as the first one, made into a negative by the slash used as in international road signs, such as those denoting "no parking" or "end of expressway." The fourth, the pointing hand, explains itself.

Prof. Louis Bazin of the Sorbonne, who helped Mr. Effel in his presentation, described the fourth symbol, a verb sign without a verb, as a sophisticated grammatical comment. In this case, he said, the word "is" has no innate meaning at all—it is merely a connective.

Many languages don't have the word, and others have separate verbs for the different uses that English gives to "to be." In French, incidentally, "that is" would be translated "voilà."

In the final symbol, the article "the" is designated by a line drawn from a legend to a specific part of a machine.

Now take this:

"Cogito ergo sum": "I think, therefore I am."

Mr. Effel adapted his symbol for thought from cartooning. Seizing a pencil, he showed in a few quick strokes that when a comic-strip character is thinking something but not saying it aloud, the words in the balloon ascend in a series of expanding rings:

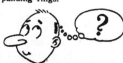

To make it easier for the typographers, Mr. Effel stylized these rings into the form shown. The curved line above it made a verb: "to think."

For the verb subject, Mr. Effel took an ancient symbol for man:

He stripped it down to a "V," which means "he," or the third person. Inverted, as above, it means the first person—I—and pointed left, the second person —you. Pointed to the right, it is the reflexive "se," or "self," which proves that Mr. Effel is, after all, French.

The phrase can easily be put into the past or the future. A short line (really an arrow, simplified) does it. Pointing right —that is, ahead, in reading— it denotes the future. Pointing left it means the past. Thus:

for "I will be," and

for "I was."

Quite complicated verb forms can be built quite simply. A question mark in parenthesis indicates doubt, so that those sad words, "It might have been," would read like this:

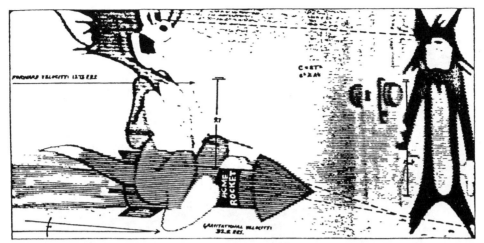

SCIENTIFIC DATA

O'Donnell's Laws of Cartoon Motion

1. Any body suspended in space will remain suspended in space until made aware of its situation. Daffy Duck steps off a cliff, expecting further pastureland. He loiters in midair, soliloquizing flippantly, until he chances to look down. At this point, the familiar principle of 32 feet per second per second takes over.

2. Any body in motion will tend to remain in motion until solid matter intervenes suddenly. Whether shot from a cannon or in hot pursuit on foot, cartoon characters are so absolute in their momentum that only a telephone pole or an outsize boulder retards their forward motion absolutely. Sir Isaac Newton called this sudden termination of motion the stooge's surcease.

3. Any body passing through solid matter will leave a perforation conforming to its perimeter. Also called the silhouette of passage, this phenomenon is the specialty of victims of directed-pressure explosions and of reckless cowards who are so eager to escape that they exit directly through the wall of a house, leaving a cookie-cutout-perfect hole. The threat of skunks or matrimony often catalyzes this reaction.

4. The time required for an object to fall twenty stories is greater than or equal to the time it takes for whoever knocked it off the ledge to spiral down twenty flights to attempt to capture it unbroken. Such an object is inevitably priceless, the attempt to capture it inevitably unsuccessful.

5. All principles of gravity are negated by fear. Psychic forces are sufficient in most bodies for a shock to propel them directly away from the earth's surface. A spooky noise or an adversary's signature sound will induce motion upward, usually to the cradle of a chandelier, a treetop, or the crest of a flagpole. The feet of a character who is running or the wheels of a speeding auto need never touch the ground, especially when in flight.

6. As speed increases, objects can be in several places at once. This is particularly true of tooth-and-claw fights, in which a character's head may be glimpsed emerging from the cloud of altercation at several places simultaneously. This effect is common as well among bodies that are spinning or being throttled. A "wacky" character has the option of self-replication only at manic high speeds and may ricochet off walls to achieve the velocity required.

7. Certain bodies can pass through solid walls painted to resemble tunnel entrances; others cannot. This trompe l'oeil inconsistency has baffled generations, but at least it is known that whoever paints an entrance on a wall's surface to trick an opponent will be unable to pursue him into this theoretical space. The painter is flattened against the wall when he attempts to follow into the painting. This is ultimately a problem of art, not of science.

8. Any violent rearrangement of feline matter is impermanent. Cartoon cats possess even more deaths than the traditional nine lives might comfortably afford. They can be decimated, sliced, splayed, accordion-pleated, spindled, or disassembled, but they cannot be destroyed. After a few moments of blinking self-pity, they reinflate, elongate, snap back, or solidify.

9. For every vengeance there is an equal and opposite revengeance. This is the one law of animated cartoon motion that also applies to the physical world at large. For that reason, we need the relief of watching it happen to a duck instead. —Mark O'Donnell

ESQUIRE/JUNE 1980

APPENDIX II
SUMMARY

Life is a set of symbols itself, from the friendly handshake, the sisterly kiss, the wedding ring, the corporate logo, the title on the door, to the final headstone. Our names are symbols. Our houses and cars, status symbols. Symbols identify us and help us relate to each other. Since cartoons are a mirror of life, it's no mystery why the symbols have become satirized and over-done. It helps us laugh at ourselves . . . and we need it.

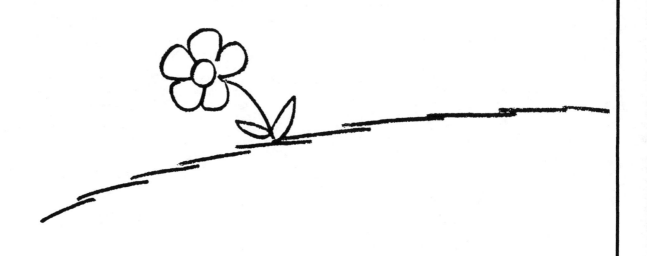

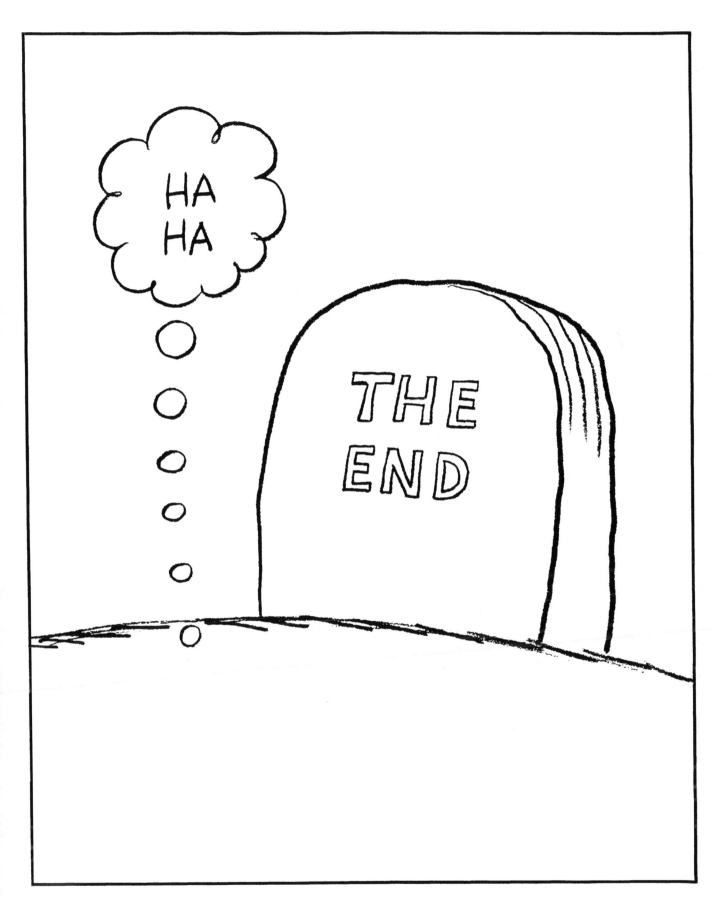

THE LAST LAUGH

$4.95	paid for this book
.50	postage and handling charge
$5.45	total cost
.02	resale value at used paper center
$5.43	your total loss

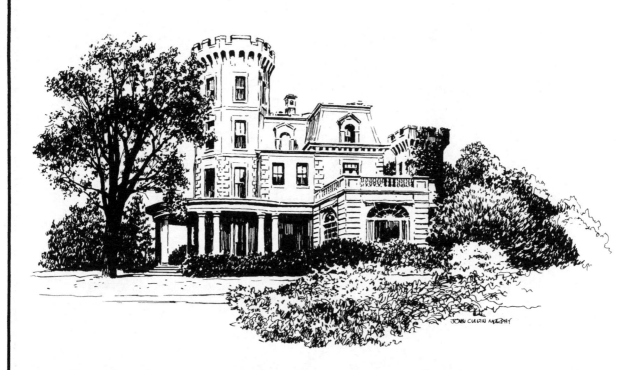

MUSEUM OF CARTOON ART
COMLY AVE. PORT CHESTER, NEW YORK 10573
TELEPHONE: 914-939-0234

In 1974, after ten years of planning and fund raising, the Museum of Cartoon Art was finally incorporated as a public foundation. It grew out of a desperate need to collect and display a unique American art form that had been largely ignored by traditional Museums. Our purpose was to rectify this situation by establishing a central location where cartoons could be protected for posterity, studied, discussed and appreciated.

The Museum opened its first exhibit at the Mead Mansion in Greenwich, CT in August of 1974, and in three years of operation, over 50,000 visitors walked through its doors. Our operations (described in detail in the following pages) branched into a variety of vital services and outside projects.

By the summer of 1976 it became increasingly apparent that we were bursting at the seams and a long, frustrating search began for a new location. Finally, after almost a year, we discovered that the fabulous "Ward's Castle" in the Town of Rye, New York was for sale. Built in 1876 by William E. Ward, a wealthy industrialist, it is the first house in the world constructed entirely of re-inforced concrete. The building was placed on the National Register of Historic Places in October, 1976 and has local significance as well, being the home of the family that dominated the economic and political life of the area for over a century.

After purchasing the castle, the Museum, co-operated closely with the New York State Historical Commission and the National Parks Service in beginning the extensive renovations necessary to bring it back to life after years of vacancy. The new Museum of Cartoon Art represents the ideal fulfillment of many purposes. The Museum now has a permanent home owned wholly by the Museum Foundation. The local community has a restored landmark that is open to its citizens and the American public has a cultural institution that preserves and promotes one of its most uniquely original contributions to the world of art and literature.

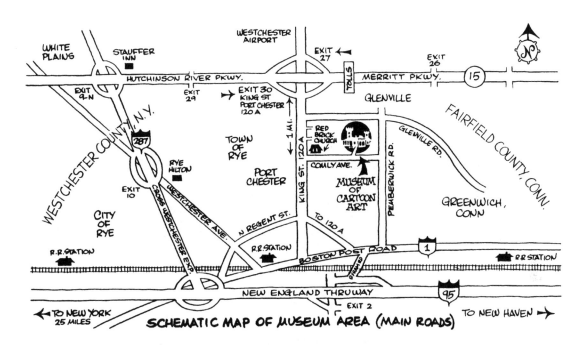

SCHEMATIC MAP OF MUSEUM AREA (MAIN ROADS)

GENERAL INFORMATION

HOW TO GET THERE: For all passenger vehicles coming from any direction, the best approach to the Museum is from the Hutchinson River-Merritt Parkway because of our proximity to the exit. Approaching from the west, take the exit marked "King St -Port Chester-120A" and, from the east, take exit 27. Proceed south on King St towards Port Chester for approximately 1 mile until you see St. Paul's Lutheran Church, which is a red brick building on your left. Just past the church, take a left onto Comly Ave. and proceed a short distance until you see the large concrete entrance gate to the Museum on the left.

Since commercial buses and trucks cannot use the Hutchinson River-Merritt Parkway, drivers should call the Museum for alternate directions

AIRPORT SERVICE: The Museum is within a short distance of all the New York area airports. For information call: Westchester Airport, 914-968-7000, or the flight and reservation numbers for the various airlines at Kennedy, LaGurdia and Newark airports

TRAIN SERVICE: The Port Chester station on the Boston-New York Conrail line is about 2 miles from the Museum. For information call: 914-939-2300

TAXI SERVICE: Kelly's Taxi Service is located directly across the street from the Port Chester railroad station and the fare to the Museum is $1.50 (50 cents for each additional person). Minibuses can also be chartered For information call: 914-939-0467.

BUS SERVICE: For information about bus routes, schedules and fares call the Westchester Department of Transportation at 914-682-2020.

ADMISSION FEES: $1 00 for adults, 50¢ for children, students and senior citizens Special group rates can be arranged

HOURS: OPEN: Tues -Fri , 10 A M to 4 P M , Sundays 1 P M to 5 P M CLOSED: Sat , Mon and all holidays See below for special hours

SPECIAL EVENTS: The Museum has a regular program of visiting cartoonist lectures on the first Sunday of each month Special events are often scheduled for Wednesday evenings as well Send for the calendar of upcoming events

FILM SHOWS· Film programs lasting 20-30 minutes each are shown to small groups, on request, during the week There are continuous film shows on Sunday afternoons, except during the first-Sunday cartoonist lectures Special film shows are also scheduled occasionally on Wednesday evenings Send for a list of film programs to choose from

GROUPS: Reservations must be made by groups of ten individuals or more. Call secretary for open dates. Maximum size of 50 visitors recommended, since Museum can only accomodate that many at one time. No groups can be scheduled for Sundays

SOUVENIRS: The Museum has a gift shop where postcards, prints, books and other cartoon-related items are on sale.

OVERNIGHT ACCOMODATIONS: The Rye Town Hilton (914-939-6300) is only a few miles from the Museum. Other local hotels are the White Plains Hotel (914-761-8100), the Stauffer Inn (914-694-5400), and the Showboat Inn in Greenwich, CT (203-661-9800).

Made in the USA
Middletown, DE
07 January 2017